Gilda Williams

BORIS
MIKHAILOV 55

Φ

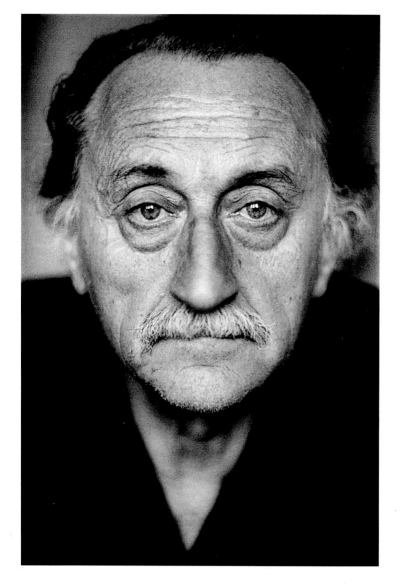

2.3

'If one were to plant woods here,' Chichikov said, 'the view would be more beautiful than — '

'Oh, so you're an admirer of fine views, are you?' said Kostanjoglo with a sudden stern look at him. 'Let me tell you, if you start chasing after views, you'll be left without bread and without views ... Never mind beauty! Concentrate on the things that matter ... Beauty will come of its own accord.' Nikolai Gogol, *Dead Souls*, 1842

'Beauty will come of its own accord.' This could be the epitaph for Ukrainian photographer Boris Mikhailov, and should probably conclude rather than open an essay about the former Soviet Union's most influential living photographer. Few of his pictures could be called visually 'beautiful' (although some are), but they have an unexpected quality of poetic or intellectual beauty that results 'of its own accord' from his art. What remains consistent across Mikhailov's work, the key to following its potentially mystifying variation, is his singular ethical purpose. The vision and courage he has sustained since the 1960s, spanning the long, hard road from Khruschev to Putin, result in this subtle beauty. The beauty of his integrity and his indomitable imagination are the most lasting impressions left by Mikhailov's art.

Yet the artist himself is the first to shift the reading of his work towards the non-beautiful, the non-intellectual, the non-political. 'A good image that conveys a sense of the beautiful and makes claim to significance makes me want to destroy that beauty and level that significance,' Mikhailov says. And, combining deep self-probing with deep self-mockery, 'One thing I really can't understand is why I look at everything through a woman's bottom.' From this delicate and unconventional vantage point, then, let us proceed.

The temptation might be, in explaining the absence of beauty or even the apparent amateurishness of many of Mikhailov's photographs, to suggest that he works as a social documentarist, recording the recent turmoil in his native land – that is, as more of a historical photo-reporter than an 'art' photographer. It is easy for Western audiences to reduce Mikhailov's work to political exposé and a voyeuristic glimpse of the unseen enemy behind and then beyond the Iron Curtain, but this is an insufficient key by which to understand his work. He is much more than that; indeed, as Russian contemporary art critic Victor Tupitsyn warned in a recent catalogue, there is probably no point at all in discussing his photographs in terms of the evils and defects of post-Soviet (or Soviet) society. Perhaps Mikhailov is a conceptual photographer (like such American and European counterparts as Dan Graham, Thomas Struth or Cindy Sherman), using photography to invent unexpected aesthetics and alternative viewpoints. Yet even this usage of photography, a practice well established in the history of Western contemporary art, is accurate for some of Mikhailov's series but barely applicable to others.

There is no equivalent Western contemporary artist who combines so many uses of photography – as conceptual project; as historical record; as the means to produce works of art and beauty; as political commentary; as self-portraiture – and it is in the unfamiliar and complicated overlap of all these forms that one can begin to approach the sequence of photographic series that comprise Mikhailov's long and varied career. His art is both conceptual and testimonial in nature. In this sense it contrasts with Western practices, where photography must be either one or the other. He variously employs a documentary approach, staged tableaux, found photography and studio set-ups; he might add tone or paint to his pictures, juxtapose

images or add accompanying texts. On occasion, he works with diptychs, or manipulates the presentation of the works so that they verge on what Westerners would call 'installation art'.

Mikhailov's motive for adopting contrasting formal strategies is to leave open the possibility for experimentation, and thus call into question the validity of a single visual response. That is, he refuses to lapse into what would effectively be a totalitarian solution to art and photography. 'I need the sum of images, sequences and series to allow me to cast doubt upon the rightness of a single possible perception,' he explains. His choices, moreover, reflect the changing moods of his surroundings. In this he is typical of the intellectual tradition of adaptability found in his homeland, as identified by Fyodor Dostoyevsky in *The Adolescent*:

'Do you know wherein lies my strength?' asked Versilov. 'In my great ability to accommodate myself to anything, which is so characteristic of Russian intellectuals of our generation. There is nothing that can destroy me, wipe me out, or, for that matter, surprise me ... Nevertheless I am aware that it is no honour to be like that, mainly because it's so practical.'

In his unique ability to have withstood some thirty years of scrutiny without falling prey to imprisonment or simply despair, Mikhailov is an extremely practical intellectual. He has maintained a continuous career of visual and ethical dissidence against the powerful and suspicious regime around him, adapting his work to respond imaginatively to his evolving circumstances. The sequence of solutions found in his many photographic series represents his unique, practical answer to artistic survival. His work stands as a remarkable historical

record – albeit from an unusually personal and idiosyncratic point of view – of the Soviet transition, 1969–2000.

The very first work Mikhailov produced, around 1965, was of a sensual and Western-looking woman smoking a cigarette. The work was hardly his ticket into the Soviet photographic establishment: rejected by every exhibition to which it had been submitted, it shockingly admitted to the existence of a hidden side of life, where people brood, smoke and have sex. Soviet photography at the time was awash with blandly paradisiacal, safe images of fertile landscapes, smiling children, androgynous citizens and lyrical still lifes. Mikhailov and his private world had no place within the existing photographic code.

His real initiation into photography – and its mortal dangers – took place most unexpectedly a few years later. In the 1960s 'post-Thaw' Soviet Union, Mikhailov was enjoying a comfortable and prestigious career as a technical engineer in a factory in his Ukrainian hometown of Kharkov. The capital of the Ukraine from the Revolution until 1934, Kharkov is a typical, anonymous provincial Soviet city in which the artist has lived all his life, save for a few years in his early childhood when he was evacuated along with his mother during World War II. His decision to remain in Kharkov and the Ukraine (which, in its modern Slavonic form, means 'on the edge') is an uncommon choice and represents a significant aspect of the artist's life and work. Nearly all of the other notable artists who emerged from the post-*perestroika* Soviet Union, the 'Sots-Art' group and others, such as Mikhailov's good friend Ilya Kabakov and conceptual painter Erik Bulatov, were based in Moscow. Mikhailov, the only important photographer to emerge from this generation of Soviet artists, has always remained 'true' to Kharkov, returning there periodically to document the frankly unremarkable city

as a symbol of the vast, forgotten body of the Soviet heartland. It marks in him a combination of stubbornness and loyalty, while testifying to his uncanny ability to find extraordinary visual events in a place where others see virtually nothing.

Mikhailov became officially interested in photography in 1966, when he was asked to produce a short film about the factory in which he worked. Welcoming this opportunity as a creative escape from his job as an engineer and the oppressive ideology of the commune, he produced the desired film. In private, however, Mikhailov also turned the camera on his wife for a series of nude photographs that were discovered and seized by the KGB. (Mikhailov's factory was located on a commune founded many decades earlier by the Soviet Union's first KGB chief.) The incident resulted in the immediate loss of Mikhailov's job – and, more importantly, in his decision to devote himself entirely to photography from that time forward. This unexpected and irreversible decision has a fable-like quality akin to Italo Calvino's *The Baron in the Trees*, about a disobedient child who declares in protest against his noble family that, having climbed the garden tree, he will never come down – and he never does. In the same way, once settled upon the branches of visual dissidence, Mikhailov remained removed and yet within his nation's confines, poised precariously above mainstream Soviet life forever, watching and recording.

Earning his living as a commercial photographer in the 1970s, Mikhailov was fully aware of the three main rules regulating photography under the Soviet regime:

1. It is forbidden to take photographs from higher than the second floor, the areas of railways, stations, military objects, at enterprises, near enterprises, at any organization, without special permission.

2. It is forbidden to take photos that bring into disrepute Soviet power and the Soviet way of life.

3. It is forbidden to depict any naked body. Only museums can display such pictures, in (non-photographic) Old Master paintings.

Mikhailov continued overtly to break the third rule, depicting male and female nudes across his many series; his dissident response to the first two rules was more subtle. Like the contemporary Iranian video artist Shirin Neshat who comments on fundamentalist Islamic society without actually breaking any of its strict regulations (including its prohibitive codes of dress and male/female segregation), Mikhailov also draws our attention to the failings of Soviet society without necessarily transgressing its rules. Indeed, he diligently follows these dictates even to the point of overstatement. In his 'Red Series' (1968–75), for example, he obeyed the second rule to the letter, photographing the rituals of Soviet public life – the tiresome, endless pageantry to the glory of the Revolution – as its failure became increasingly transparent. The insincerity and the undercurrent of fear behind these celebratory events – the unsmiling faces of bored citizens forced to march gaily in a parade; the dull, militaristic public display of agricultural machinery, festooned with garish decorations – is revealed with biting clarity. Yet the subject matter throughout obediently adheres to the rule requiring respectful depiction of official Soviet life. Similarly, in the series 'By the Ground' (1991), Mikhailov did not lift the camera above waist level – let alone past the second floor – to document the dusty pavement, the homelessness, the dirt and poverty of the decaying street life of Kharkov and Moscow. The camera recreated the gaze of downcast eyes among the Soviet citizenry walking its tired streets, depressed and hopeless – and yet did not stray beyond the oppressive dictates of the regime.

Such subtle acts of dissidence always need to be decoded in Mikhailov's work. The photographs act simultaneously as literal records and as metaphors with which the viewer must intellectually engage. At times, they must do so physically as well. When the 'By the Ground' series has been exhibited (at New York's Museum of Modern Art, 1993–4, and elsewhere), the pictures have been hung at the bottom of the wall, almost at floor level, replicating the height at which the photograph was taken, but above all forcing the viewer to bend into the uncomfortable positions of the unhappy subjects depicted. Looking at Mikhailov's work is never a passive activity, but an involving, even confronta- tional experience. And yet the work can also stand independently, outside its conceptual framework, and can be appreciated for its photographic merit alone, for its 'originality of vision' (a notion associated with the traditional assessment of photography). In a sense, Mikhailov has it both ways: his work critiques the conventions of photography, questioning its ability to produce 'truth', whilst in the meantime taking advantage of the photograph's real ability to produce art and to document his native land. In this, once again, Mikhailov is not only practical but thrifty, exploiting the impact of each image for every possible usage, political and aesthetic.

Western viewers sense immediately that they must become at least partially informed of the social history behind these photographs in order to come to terms with them, and this too requires interactivity. In an early and important body of work, the 'Luriki' series (1971–85), Mikhailov borrowed from a peculiarly Soviet tradition. In the 1970s, he was still working as a commercial photographer, earning his living by retouching and colouring ordinary family photographs – smiling babies, holiday memories and awkward couples – according to the tastes of his clients. As was common in the Soviet

Union, Kharkovian families would enlist the services of a professional photographer to transform their snaps into enlarged, 'painterly' portraits to be displayed proudly on the living-room wall. Black-and-white family pictures were coloured in lurid yet conventional ways: subjects were idealized with rosy cheeks and blood-red lips, while physical imperfections were removed for ever. Even the dead could be resurrected, as open eyes were painted over the permanently closed lids of a deceased relative. Mikhailov saw in this vast archive of family photography an ongoing visual tradition that had miraculously escaped official control; yet even here, ordinary Soviet citizens – like their high political counterparts – felt free to manipulate the 'truth' of the photographic image.

In one 'Luriki' photograph, a smiling baby girl with hideously teased, clown-like hair (a wig?) lifts her skirt to exhibit strangely swollen genitalia. The unease of this picture is typical of Mikhailov. On one hand it is an innocent pose, and the picture represents such universal and banal subject matter that this baby could seemingly come from anywhere. And yet she seems marked as unmistakably Soviet. Her nakedness is more obscene than it is childishly appealing, just as the nakedness in many of Mikhailov's pictures is more animalistic and crudely sexualized than it is erotic. Her innocence is undermined by a freakishness and even a sense of doom as she affects almost instinctively this precocious 'soft-porn' pose. In light of the sex industry that blossomed and was so widely exported in the aftermath of *perestroika*, when this toddler would have grown into a young teen, the picture takes on an unpleasantly prophetic tone. And if this is to read too much into what is, finally, 'just' a baby picture, the discomfort produced by the cheaply painted image hints that never, not even in the fleeting bliss of earliest childhood, is there a purely beautiful, optimistic and uncorrupted moment, however brief, in the course of Soviet life.

In series such as 'Luriki', Mikhailov reveals photography as a medium regularly used to invent events and memories, and to distance subjects from their own reality. Even as the photograph contradicts its truthful nature (as an allegedly objective document mechanically recording the world around it), and either tells lies or glosses over the dissatisfactions concealed behind the 'pretty picture', in Mikhailov's hands it paradoxically exposes the unease and the disappointments of everyday life. That is, the picture is inadvertently honest (intending to idealize) yet fails to disguise a genuine sadness – just as Mikhailov's work can be inadvertently beautiful, despite its attention to the harshness of Soviet reality. The 'truth' in these pictures lies in the artist's own self-probing sincerity and in the viewer's efforts to read the work intelligently; their truth does not lie in the literal veracity of the image itself, which Mikhailov treats with utter scepticism. All images, he seems to say, are ideological, never innocent. As critic Diane Neumaier has observed, Mikhailov shows us a photograph, and simultaneously reveals how the medium works, as if exposing the ideological machinery hidden behind it.

Mikhailov often poses as an amateur photographer, as he did with the found images of 'Luriki', in order to seek out the inherent condition of the photograph as it has been applied to non-art practice. In this way he connects to traditional revolutionary artists, who drew on folk or popular art as a kind of democratic impulse. In the early days of the Soviet Union, photography was privileged as the visual means capable of both describing and projecting the patterns of social evolution under Communism. Lenin himself said of photography that it could contribute to the consolidation of Soviet Socialism by being 'imbued with Communist ideals and by reflecting Soviet reality'. Often, Mikhailov is considered the heir to Alexander Rodchenko, one of Russia's most significant

modernist artists, who turned away from painting in the 1920s–30s in order to adopt photography as the means to demonstrate the benefits of the Revolution. Rodchenko believed that the camera could construct reality in a new way, due to the 'democracy' of the image. In his autobiography of 1939 he wrote:

… Then he began to photograph.
In his hands the nickel and glass black Leica
He went to work with joy.
Now he'll reveal the world
From a new viewpoint
The familiar and the everyday world.
He'll reveal the people and the building of socialism.

Whereas Rodchenko proudly documented the Soviet 'after' to contrast with the oppressive Tsarist 'before', Mikhailov has photographed a long transition, as life returns to pre-Revolutionary conditions at the close of the century in a kind of tragic cycle. The experimentation in Mikhailov's work has been in response to the changing and precarious social conditions around him, which accounts for its almost schizophrenic stylistic unevenness. When Soviet society was struggling with dwindling resources in the early 1980s, Mikhailov created his 'Series of Four' (1982–3), in which quartets of separate images were printed on a single sheet of photographic paper. The artist could thus save on scarce supplies while using this technique to heighten his longstanding desire to prompt free association between different images in the viewer. When capitalism began to seep into 1990s Ukraine, he experimented with paying his subjects to pose for him, thereby entering into the mechanisms of the market and participating directly in the economic shifts within his society. In 'Case History' (1997–8), for

example, he hired the homeless as subjects. From found photographs ('Luriki') to cinematographic vistas ('By the Ground'), from staged self-portraiture ('I Am Not I', 1992) to social documentation ('Case History'), the variety of Mikhailov's strategies not only reflects the richness of his imagination, but also his survivalist, practical solutions in an unstable, unsafe world.

Mikhailov's work seems continually to ask, how can an artist position himself in a defeated and dying society? At what distance can she or he safely and morally hold the camera? In answer to this ethically irresolvable question, Mikhailov remains firmly grounded in the real circumstances around him. He is conscious of the ethical importance of documenting Soviet reality and recording the true effects of the failed 'world experiment' (as he calls it) that took place in the Soviet Union (and was deliberately misrepresented or ignored in official channels). As Mikhailov notes: 'In the history of our country we do not have photos of the famine in the Ukraine in the 1930s when several million people died and the corpses were lying in the streets. We do not have photos of the war, because journalists were forbidden to take pictures of sorrow threatening the moral spirit of the Soviet people. We do not have non-lacquered pictures of enterprises, nor pictures of street events, except demonstrations. The entire photographic history is dusted. And we have the impression that any person with a camera is a spy.'

As a Soviet citizen conspicuously holding a camera, then, Mikhailov accepts that he is performing the role of a kind of spy. 'As a photographer endowed with unofficial authority, I, in some way, track down, spy, sneak,' he has said, 'and the most important thing is to define after whom.' But while the government spied to exert control and create a generalized climate of mistrust and fear,

Mikhailov admits his search is mostly for himself; seeking to discover his reasons for continuing this spying, experimenting and documenting. 'If you look through binoculars, you sneak after someone. If you look through a camera you are also sneaking after yourself,' he says. This idea was literally imaged in the series 'Crimean Snobbery' (1982), picturing Mikhailov and his friends, and even more explicitly in 'I Am Not I', self-portraits in which he parodies his own artistic persona.

Yet in some way, all of Mikhailov's photographs are self-portraits: both artist and image are the human result of the merciless Soviet political and social system. That system determined the choice of his very profession and lifelong pursuit of photography, resulting from the absurdities of chance and the paranoia of official culture. Mikhailov cannot but document his own state of mind, reflected in his photographs of contemporary Soviet and post-Soviet culture. Unlike most Western social documentarists, who assume a critical distance in order to accuse and comment objectively upon their environment, in his pictures Mikhailov confesses to belonging to the Soviet routine. 'In my work,' he has said, 'I identify with the period and process our country is going through.' This explains the subtlety of his critique of Socialism and its after-math: since he is thoroughly embedded within that system, any commentary becomes a kind of self-examination.

The theorist Pierre Bourdieu has famously commented on the universal use of the ordinary camera in commemorating family events. He wrote: 'The photo-graphic practice only exists and subsists for most of the time by virtue of its family function ... namely that of solemnizing and immortalizing the highpoints of life ... reinforcing the integration of the family group.' In Russia and the

Ukraine, the common family photograph has a political valence as well. During the 1930s, Soviet citizens were not permitted to have cameras in the home; it was a punishable offence, and very few family photos from that period exist at all. For this reason, Moscow-based critic Victor Misiano has described Mikhailov and subsequent photographers as generations marooned, 'photographers without photography', raised without access to this most democratic and familial of media. In keeping with Bourdieu's observation on family photography, it is as if when Mikhailov could finally turn his camera on the Soviet family, the celebrations of home life had been reduced to emotionless Socialist parades, the beloved family patriarch to a rigid statue of Lenin. The family unit itself, especially in 'Case History', resembles a pack of wild dogs more than a human group. To cite Victor Tupitsyn again, Mikhailov's optic is 'affectionate, yet negative and phobic'. He is like the persistent family member who continues to snap the shutter even through an embarrassing domestic crisis. As his fellow family members beg him to stop 'for the sake of decency', he continues to immortalize them, still seeing in them both the reflection of himself and the fond memory of a cherished yet distant family.

Untitled, Kharkov, Ukraine, late 1960s. Describing the bleak Russian country-side in his story *The Steppe* (1888), Anton Chekhov wrote with biting pessimism that 'the landscape was punctuated by cheerful white crosses' – as if the cross-shaped tombstones, the promise of death, were the only relief in the dreary Russian life and landscape. In this early photograph, the only hint of life in the dismal urban landscape are the red poles of the stop lights, punctuating the eventless intersection of deserted streets. Mikhailov has spent his entire life in this industrial city. 'Kharkov is my place in a very real sense,' he writes. 'I think the West has too many distractions that can be a hindrance to my work.' Kharkov's total lack of distractions are in plain view here.

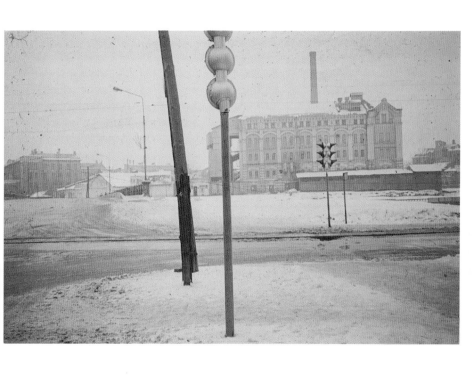

Untitled, from the 'Superimposition' series, Kharkov, Ukraine, late 1960s.
Works from this series, in which two slides are projected one over the other, were first shown publicly almost fifteen years after Mikhailov had conceived the idea. Even then they were received with great hostility from unprepared local art critics, one of whom declared that they were an offence to the very idea of photography (as a 'singular' picture of truth). However, they were much applauded by the large audiences who gathered to see them. Here, a female nude (forbidden subject matter in the Soviet Union) reclines on a carpet — perhaps a magical vehicle on which to fly away? Her flesh is overlapped with text; contrasting 'low', potentially pornographic imagery with 'high' literary tradition.

горячий солнечный свет, про медовые
кашки. Весёлый Желтухин опять
пошёл осматривать помещение.

 Упражнение

Как? хорошо, стойко, ...
Где? здесь, тосл, впереди
Куда? налево, вдаль, вперёд
Когда? ..., сейчас
Откуда? ... сверху ...

Untitled, from the 'Superimposition' series, Kharkov, Ukraine, late 1960s. When Mikhailov first accidentally put two slide films together, he claims he found an ideal technique for combining overt message-making with free association, the paradox behind much of his work. Here, a woman is surrounded by a swarm of giant flies (a symbol also used by fellow artist Ilya Kabakov for a grey, collective society) as if descended upon by bombs or fighter planes. These overlaps update such post-Revolutionary traditions as the discontinuous images in the films of Sergei Eisenstein, or the photomontages of El Lissitsky. As was true for Mikhailov's predecessors, fusing opposites and incompatibles is a way of visualizing the non-linear processes of the subconscious, producing new and surprising connections.

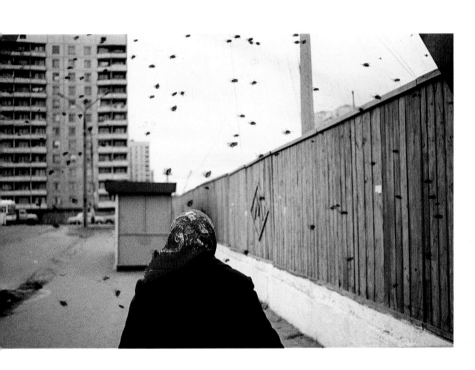

Untitled, from the 'Red Series', Kharkov, Ukraine, 1968–75. The 'Red Series' is a group of photographs in which the colour red – a ubiquitous symbol in Soviet society – is included as incidental background. Mikhailov documents a tiresome world dominated by flags and political demonstrations, portraits of Lenin and official awards ceremonies; the alleged festivities contrast sharply with the dullness of the events depicted. This attempted celebration is populated by middle-aged, decorated demonstrators who hold huge, garish flowers – yet not so much as a hint of amusement crosses their joyless faces. Without breaking any of the strict rules of Soviet photographic policy, Mikhailov reveals the unhappiness and contradictions boiling just beneath the surface of 1970s public life.

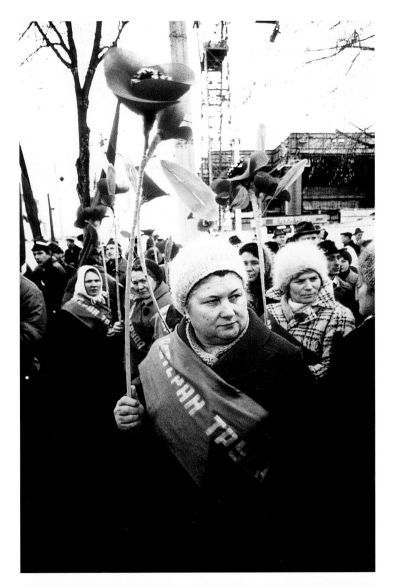

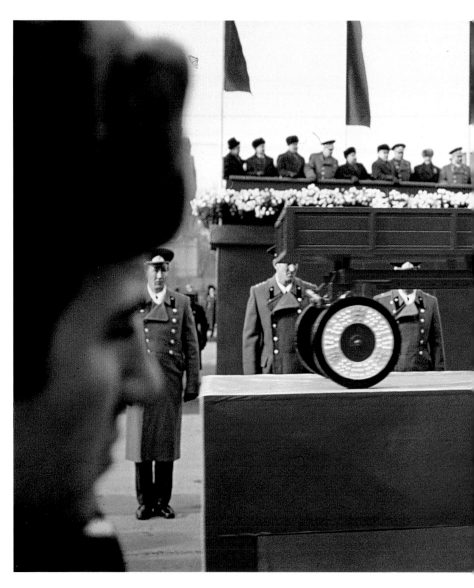

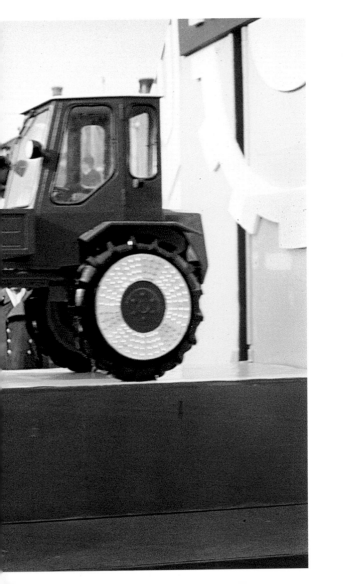

(previous page) Untitled, from the 'Red Series', Kharkov, Ukraine, 1968–75. In 1993, American artist Charles Ray parked a giant replica of a toy fire-engine – a glaring, red symbol of excess and abundance – on a New York street. The tongue-in-cheek humour in Ray's playful work is echoed by Mikhailov's photograph of a tractor, solemnly displayed and jealously guarded; yet there are plainly no smiles in this picture. To Western eyes, this ritualistic elevation of a farm vehicle is typical of the imagined dreariness of Soviet life. Yet Mikhailov does not, as Western social documentarists often do, emphasize the drabness of the event, but actually enhances (through artificial coloration) the variety of reds depicted – the flags, the grandstand, the truck and decorations – as if slyly 'supporting' the celebrations.

Untitled, from the 'Red Series', Kharkov, Ukraine, 1968–75. One of Mikhailov's most beautiful and celebrated nudes, this is an unusual work. Often, he deliberately adopts the cheap materials, techniques and props of Soviet art-making to ensure that he remains well within the bounds of his country's traditions. Here, the simple combination of a voluptuous female body and a garden hammock results in a surprisingly rich and highly sculptural nude. As part of the recurring contrasts in Mikhailov's work, the regular, geometric pattern of the hammock acts as a foil to the lush shadows of the sunlit flesh.

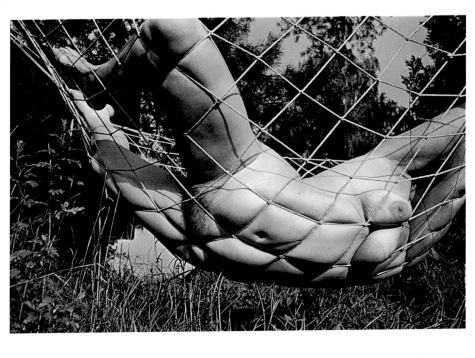

Untitled, from the 'Red Series', Kharkov, Ukraine, 1968–75. This decorated elderly man stares blankly, a red cloth draped behind him in a gesture of feigned grandeur. It is the final image in the 'Red Series', which began with the portrait of an eager young boy, and seems to close a life cycle. Once again, Mikhailov adopts and updates his country's artistic traditions. Red has been a favourite Soviet colour since the Russian icon painters and grew in importance with poster artists and Social Realists after the Revolution. It represented the 'blood of the martyrs and the fire of faith', the proletariat classes, the Soviet flag. Yet in Mikhailov's work it seems to symbolize unfulfilled promises and desperate, failed attempts to triumph in the face of disillusion.

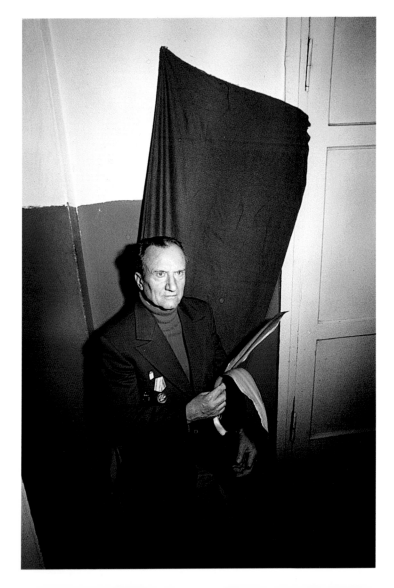

Untitled, from the 'Calendar' series, Kharkov, Ukraine, late 1960s. The female nude was forbidden subject matter under the Soviet regime. When the KGB discovered he had taken nude photographs of his wife, it cost Mikhailov his job. At the time, the artist had been warned that 'although he was allowed to see certain things, he was forbidden to photograph them'. Here, Mikhailov depicts two taboos simultaneously: the naked body and the act of urination, subject matter barely acceptable anywhere (except in Western hard porn). Yet this photograph, with its contagious sense of *joie de vivre* and childlike play, evokes neither shame nor eroticism.

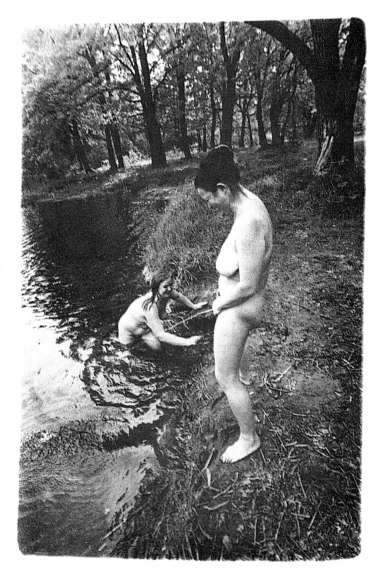

Untitled, from the 'Calendar' series, Kharkov, Ukraine, late 1960s. The 'Calendar' series is a group of twelve sepia-toned female nudes. Referencing Western pin-up calendars and playmates-of-the-month, nudes like this odalisque-type figure adorned with lacy shadows are more political than might be immediately apparent. The female figure in official Soviet iconography was an androgynous and sturdy member of the workforce. Although these images of the naked, sexualized female seem at ideological odds with the strong feminist images produced in the West during this period, in the Soviet Union they were also images of political dissidence, departing radically from the prevailing man-made ideal of woman as heroic worker.

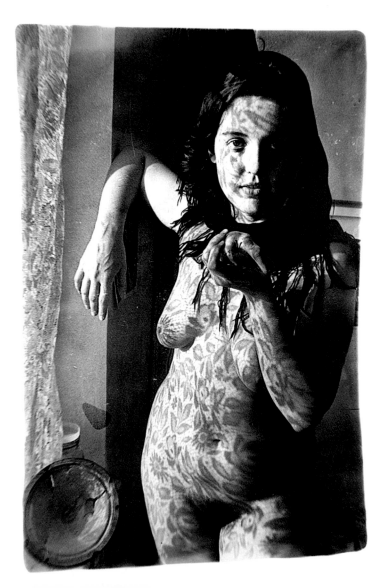

Untitled, from 'Luriki', Kharkov, Ukraine, 1971–85. 'Luriki' is a term invented by Mikhailov and derived from 'zhmuriki' ('those who wink or blink'), the name by which itinerant funeral musicians refer to the dead. In the 1970s, Mikhailov earned his living as a commercial photographer, retouching and colouring family photographs. The rules for these embellishments were prescribed: the cheeks were coloured pink, the grass green; physical imperfections were removed. Mikhailov applied these conventions in photographs such as this, taken from his own archive. The 'Luriki' series provides the first instance of found materials used in contemporary Soviet photography, a strategy that has since been adopted by many of Mikhailov's younger colleagues.

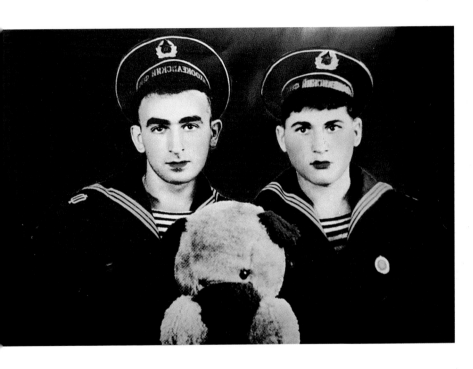

Untitled, from 'Luriki', Kharkov, Ukraine, 1971–85. 'I find that colouring photographs and using family albums gives me a chance to say more about the Soviet Union and its inhabitants than has been said in all [my] photographs before,' the artist once said. Presenting ordinary family photos, the 'Luriki' bring to mind the post-Revolutionary, politically charged tradition of incorporating folk traditions into high art. Thus, Mikhailov could identify his art-making practice with the country-fair painter or amateur photographer rather than the 'professional' artist. He was fascinated by this sea of anonymity – ordinary snapshots of cherubic children, Komonsol youths, stiffly posed couples – at once memorable and grotesque, flowing against the tide of official image-making.

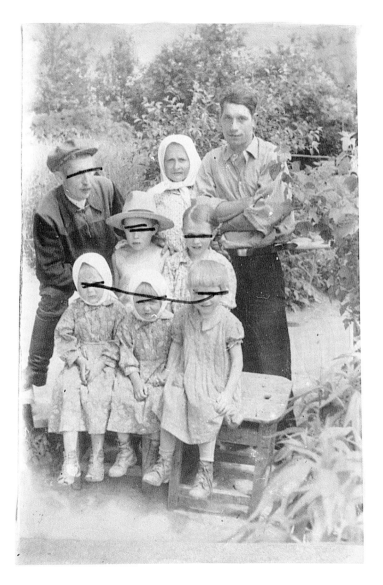

Untitled, from 'Luriki', Kharkov, Ukraine, 1971–85. In this series Mikhailov colours the faces of his nameless compatriots. In the days when Soviet policy determined the nature of most photography, such domestic pictures provided one of the few opportunities for private citizens to create images as they pleased. This key series publicly acknowledged for the first time a thriving visual tradition independent of official Soviet culture. It is unclear whether Mikhailov is mocking popular taste or revelling in it, offering a homy picture of Soviet life or a cruel, alienated one. By colouring these photos, is the artist defacing precious family mementos or making them more precious, more 'painterly'? In either case, the hand-painted touch lends them an air of nostalgia, even of death.

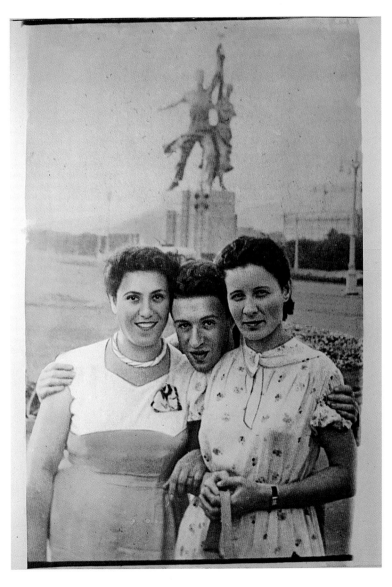

Untitled, from 'Luriki', Kharkov, Ukraine, 1971–85. By folding this hand-painted, found photograph, Mikhailov creates a humorous yet violently distorted portrait of an anonymous Soviet citizen. In these manipulated black-and-white photographs, the artist refers in a subtle way to the notorious Soviet tradition of constructing and reconstructing reality through 'customized' photography. At the same time he echoes, in specifically Soviet terms, the work of numerous Westerners – from Marcel Duchamp's readymades to Andy Warhol's painted Marilyns to Roland Barthes' concept of 'the death of the author' – while pre-empting the found-photograph strategies of Sherrie Levine, Richard Prince and others in the 1980s. Mikhailov considers these breakthrough works to be his first conceptual photographic series.

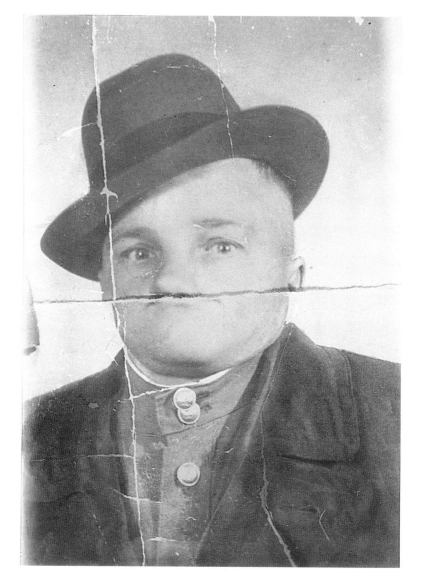

Untitled, from 'Sots Art', Kharkov, Ukraine, 1975–86. In the 'Sots Art' series Mikhailov returned to taking the photographs himself, this time focusing his attention on political and ideological subject matter. Like the 'Luriki', the works are hand-coloured. The 'Sots Art' series updates the Lubok and Rosta Window traditions – uniquely Soviet forms of visual propaganda in the early days after the Revolution – in which easily understood folk images were painted in garish colours and widely distributed. They were traditionally used for allegorical commentary, political communication and the portrayal of events in the new Soviet Republic. This photograph of young gymnasts falling somewhat short of the physical idealization of model Soviet athletes encapsulates the sense of discomfort and subtle political critique running throughout the series.

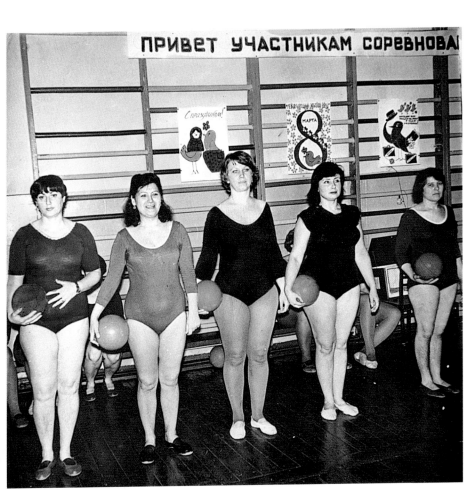

Untitled, from 'Sots Art', Kharkov, Ukraine, 1975–86. In one of Mikhailov's best-known and most extraordinary photographs, two young boys are transformed into monstrous twins by their matching gas masks. They stand awkwardly to attention in a dismal interior, presided over by an approving adult and a portrait of Lenin. The youths look like alien boy scouts, exchange students from another planet, benefiting from the Soviet Union's then-thriving space programme. Mikhailov manages here to transform a simple event into an emblem of Soviet life: the incongruity of the outdated gas masks in a country at war only with itself; the bleakness of the room 'gaily' painted pink; the obvious discomfort of the boys who have become almost subhuman through the trappings of Soviet life.

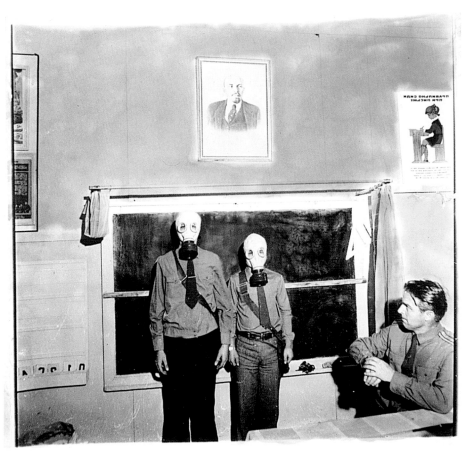

Untitled, from 'Sots Art', Kharkov, Ukraine, 1975–86. As the critic John Jacob has noted, by colouring the two monuments on either side of the image as well as the furry hat and the fruity filling of the cakes, Mikhailov reminds viewers that the comfort and pleasures on offer (the warm hat, the doughy cakes) are directly related to the ideology propagandized in the two flanking signs. Behind the red-cheeked woman and the pastries a monument to Gorky soars into the sky; the resulting image is a kind of photographic allegory about the contrast between the bitterness and sweetness of Soviet public life.

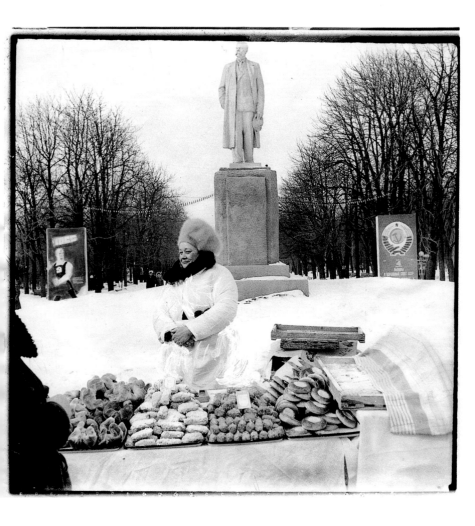

Untitled, from 'Sots Art', Kharkov, Ukraine, 1975–86. In this series we see Soviet society dissolving before our eyes, signalled by the obvious incongruity between the tired faces of the citizenry and the pageantry of the events. Here, gloomy men and women are forced to march in political demonstrations. Elsewhere, we see other examples of the endless rituals of provincial political life: law-abiding citizens at the voting booth, or over-regimented military-training routines. Through these photographs of official Soviet life, Mikhailov subversively ridicules the regime while cleverly staying within the law.

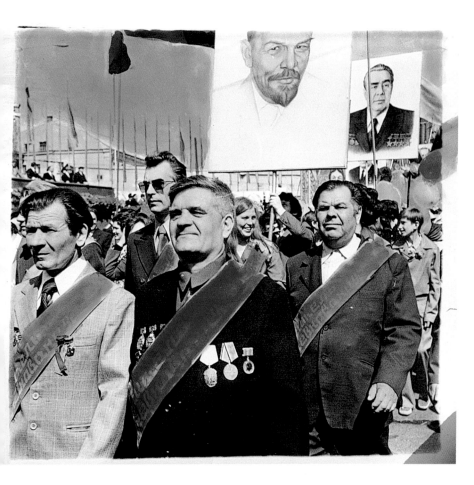

Untitled, from 'Sots Art', Kharkov, Ukraine, 1975–86. Although in this series Mikhailov usually painted his anaemic black-and-white prints to match the contours and 'natural' colours of his subjects, in this example he again borrows from amateur or poster artists to replicate the graphic effects of flat expanses of colour. The unnatural colouring underscores the artificiality of the scenes in which absurdly enthusiastic tennis players celebrate the joys of Soviet sport. Mikhailov manages to draw these pictures into the acceptable imagery of mainstream Soviet mythology while also attacking it and pointing out the inanities of Socialist Realist photography and painting.

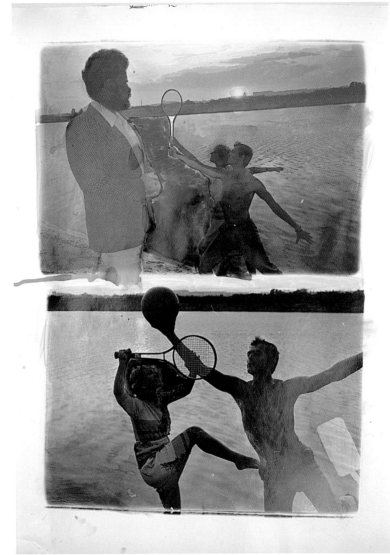

Untitled, from 'Beach at Berdiansk', Ukraine, 1981. In this series (as in 'Crimean Snobbery', made the following year), Mikhailov photographs Soviet people 'getting away from it all'. These sepia-toned photographs were arranged in the form of a book, each picture centred on a page and surrounded by wide white margins – unusual for Soviet photo albums, which usually feature dark paper. In toying with this sleeker, more modern or 'international' form of presentation, Mikhailov wishes to place his subjects as if in the flow of a historical development that bypassed his country. Can these people, lost behind the Iron Curtain for decades, ever be reintegrated?

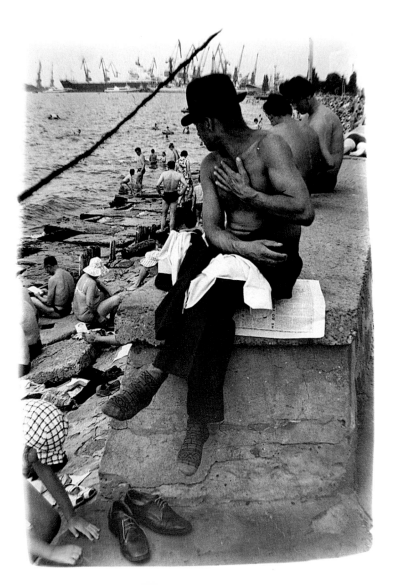

Untitled, from 'Beach at Berdiansk', Ukraine, 1981. Three young men put their heads together in sunlit, sleepy conversation, as if conspiring – or dreaming. The 1980s in the Soviet Union was a turbulent time, with each political scandal topped by the next, one General Secretary replaced by another. Here, Mikhailov presents a far more innocent kind of 'conspiracy', the trio of vacationing boys forming their own private alliance before rolling lazily off into the nearby sea. With this subtly erotic image, Mikhailov demonstrates his almost effortless ability to create beautiful, measured, pictures; such works deliberately contrast with other series in which Mikhailov more obviously experiments with amateur or even 'ugly' photography. The overall result produces the extraordinary variety that characterizes his oeuvre.

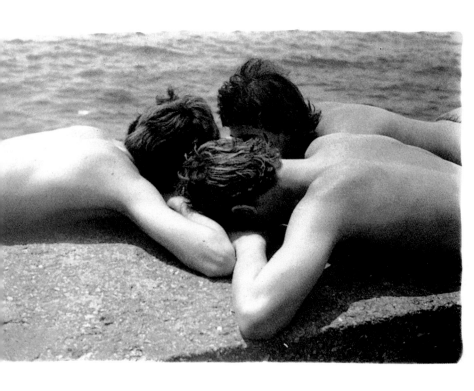

Untitled, from 'Beach at Berdiansk', Ukraine, 1981. Some of Mikhailov's photographs have a distinctly cinematographic quality; candid shots look almost as if they could be stills from French or Italian movies from the 1960s. The perspective in this group portrait, the distinct layers of foreground, middleground and background, creates a film-like depth that suggests a kind of narrative. In explaining the non-eventfulness of such pictures, Mikhailov has said, 'The more we exclude *sobytie* [event] from representation, the closer we can approach the most important thing: being.'

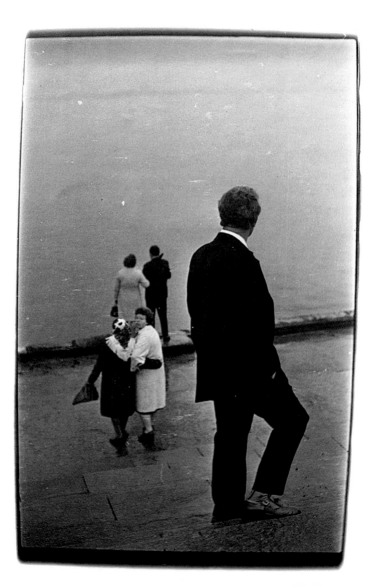

Untitled, from 'Crimean Snobbery', Gurzuf, Ukraine, 1982. Mikhailov and a group of friends cavort in front of the camera in this tongue-in-cheek, staged series taken at a seaside resort in the summer of 1982. He pictures himself and his companions as the free citizens of Somewhere Else, in a life filled with joy and sensuality rather than the usual struggles with bureaucracy and the meaningless rituals of Soviet life.

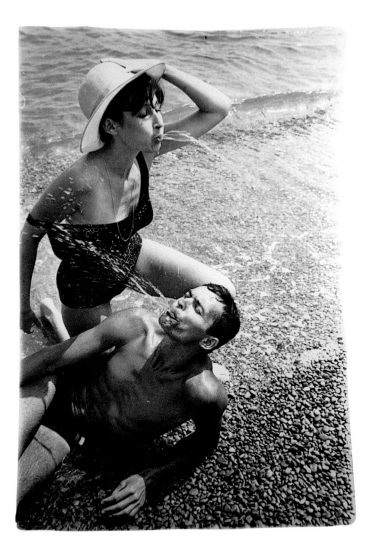

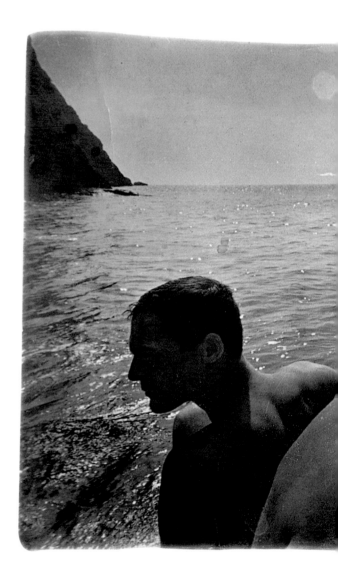

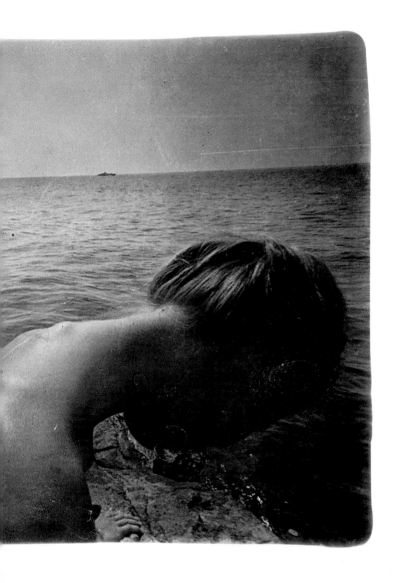

(previous page) Untitled, from 'Crimean Snobbery', Gurzuf, Ukraine, 1982. Beautiful sunlit nudes such as this mask a quiet political undercurrent throughout Mikhailov's work. While such seductive images are fairly common in Western iconography (especially in advertising, fashion and 'art' photography) they by no means accord, either morally or visually, with the prescribed USSR policy. Series such as 'Crimean Snobbery' are a fascinating and complex combination of languages — at once dissident and non-political; Soviet and Western; posed and candid; humorous and nostalgic. Such contradictions are the mark of Mikhailov's constantly changing perspective.

Untitled, from 'Crimean Snobbery', Gurzuf, Ukraine, 1982. In this staged photograph, taken at the seaside resort town of Gurzuf, Mikhailov portrays the carefree life of moral, aesthetic and personal freedom not permitted in his homeland. The artist himself hams for the camera like a film star, *Dolce Vita*-style. Behind him sprouts an exotic palm leaf — a cheap prop to suggest the Riviera or a distant island paradise. These works can be compared to self-portraits by the American artist Cindy Sherman, whose 'Untitled Film Stills' and later series similarly question the 'truthfulness' of the photograph, its ability not just to document the truth but to stage convincing deceptions.

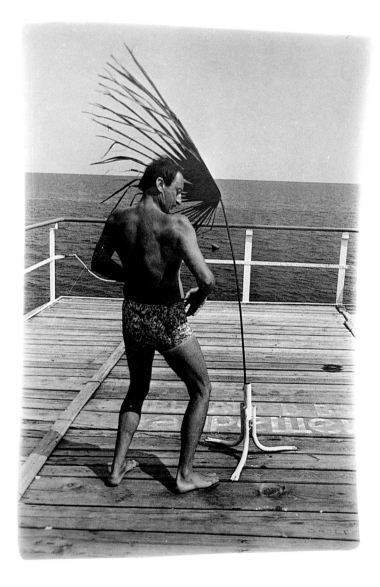

Untitled, from 'Viscidity', Kharkov, Ukraine, 1982. In this series Mikhailov continues his work with staged photographs begun in his previous two series. To this new group of pictures he added notes (hand-written in crayon and pencil) to layer the images with unexpected associations. The text accompanying this comical self-portrait of the artist reads: 'A Walk in the Rain. At the Young Pioneers camp I was sent to gather tomatoes. One tomato slipped into my trousers. When I tried to get it out, they all laughed.'

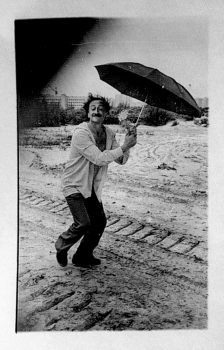

Прогулка в дождь

а в пионерском лагере нас
взяли убирать помидоры
один подсел ко мне в штаны
нагально
и когда я вынимал его все смелись

Untitled, from 'Viscidity', Kharkov, Ukraine, 1982. 'Sometimes I freeze … especially when I find objects and places that help me to do so. I do not get distracted, I do not get excited, I do not go through anything. I do not remember, etc. Sometimes I freeze, even when people are waiting for me, because no one can take that away from me.' The above is the hand-written text accompanying this black-and-white, sepia-toned photograph of a concrete barrier in an empty expanse of Ukrainian countryside. These texts are not meant as captions or poems; they can be philosophical, lyrical or autobiographical statements which are meant to prompt free associations.

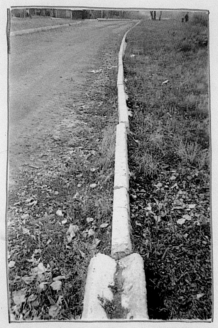

Иногда я застываю...

Иногда я застываю...
Особенно когда нахожу предметы и места,
которые мне в этом помогают.
(я не отвлекаюсь, не возбуждаюсь, не
переживаю, не вспоминаю, не умю
и т.д.)
Иногда я застываю, даже когда меня
ждут.
потому что это у меня могут не
отнять.

моя школа. 1ᵃ школа ч. Ленина

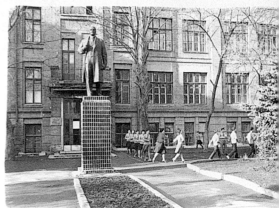

памятник поставили уже после
нашего окончания школы.

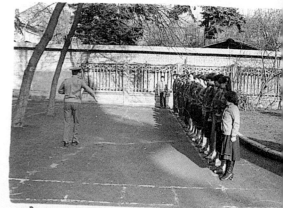

Военное дело у нас тоже было
только форму одинаковую всем
недавно

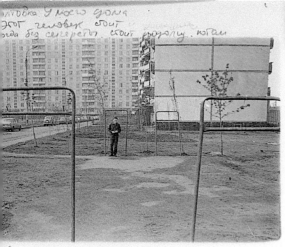

площадка у моего дома
Этот человек стоит
огда без сторожа стоит ворота. когда

встанет на другое место и
улыбается

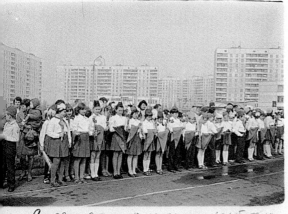

9 мая Дети с пионерскими галстуками
и в синих пилотках Голубики еще белые и бывают и др
пионерский галстук. Это красные треугольники
киноски мотерия. их повязывают на шею когда
детям становится ... лет

(previous page) Untitled, from 'Series of Four', Kharkov, Ukraine, 1982–3. 'With the beginning of *perestroika*,' Mikhailov has said, 'life changed for the worse.' This series, in which four images are printed on a single sheet, arose more or less by chance due to a shortage of photographic paper. The artist liked the effect: unexpected associations arose between images, and at the same time the works became a metaphor of the struggle for resources – as well as for art and beauty – in Soviet society. Here we see young Kharkov children lining up in a schoolyard drill taken from a variety of angles, presided over by a statue of Lenin and by cheap residential tower blocks.

Untitled, from 'Series of Four', Kharkov, Ukraine, 1982–3. These four images create a kind of narrative as Mikhailov observes a dark-haired young woman holding a balloon. In this series, pictures of Kharkov landscapes, bus passengers or women at a beauty competition are combined into groups of four causing the viewer inevitably to draw connections between them. This work (reminiscent of American artist Vito Acconci's *Following Piece* (1969) in which he tails and photographs strangers on the street) has a somewhat sinister quality – why is the photographer pursuing this unsuspecting woman? – tempered by the stagey-looking prop, the stark, white balloon. The end result is like a flip-book sequence which produces a film-like effect.

О шарике

шарик справа...

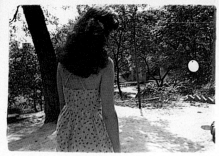

и девушке

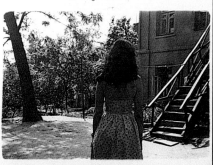

шарик слева...

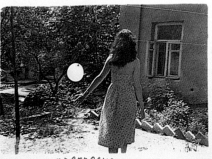

прекрасно

Untitled, from 'Unfinished Dissertation', Kharkov, Ukraine, 1985. Made up of 880 sheets of cheap drawing paper, each with one or two photographs casually glued to the surface, this series exists on the back of an unfinished dissertation found by Mikhailov in the early 1980s. By adopting the abandoned text as the literal backdrop for his work, Mikhailov creates a symbol of lost hope — long, devoted hours of labour that yield nothing — and the sense of doom in the Soviet Union, where everything is ultimately reduced to scrap. Mikhailov redeems the anonymous efforts of this failed dissertation candidate by saving the essay from the rubbish heap and transforming it into a work of art.

Если вошёл, хорошо имей
возможность выхода.

и это вообще годы детективную концепцию
т.к. это надо иметь

Мираж классики —
замкнутость в самом произведении —
близок религиозного мироощущения,
но ведь оно изменилось.

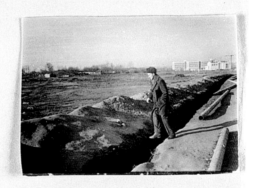

Не в вечности

а может знание и не должно
оставаться

а должно просто распространиться

Не в вечности

Но мы придём

и мы уйдём

Untitled, from 'Unfinished Dissertation', Kharkov, Ukraine, 1985. 'Unfinished Dissertation' was conceived in the early 1980s when Mikhailov had lost interest in the Western cultural production that reached the USSR. The result is a self-made artist's book with no chance of ever being published. The artist follows his country's tradition, beginning in the 1920s, of cheaply printed magazines through which artists and intellectuals disseminated radical new artistic practices (later on they were used to spread Soviet propaganda).

Феноменология

Феномен — это не явление чего-то (сущности) а того, что само себя обнаруживает как предмета непосредственно явленного сознанию

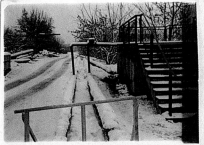

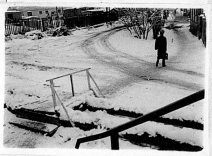

Феноменология — это интуитивное усмотрение идеальных сущностей (феноменов) обладающих непосредственной достоверностью

Untitled, from 'Unfinished Dissertation', Kharkov, Ukraine, 1985. Here, as in other series, Mikhailov adopts the aesthetic of an amateur. He wished to deny the aesthetic pleasure derived from photography and pursue, in his own words, 'the experimental method of an amateur who wants to develop and print all his films at night in the toilet ... It is the continuation of the style of Soviet society, inadequate and unquestioned.' The torn paper of the unfinished dissertation itself is the artist's subtle commentary on the vulnerability and devaluation of academic and intellectual efforts in the Soviet Union. At the same time, it connects to the homemade, text-and-image practice of Western Conceptual artists in the 1960s and early 1970s, such as Hans Haacke and Douglas Huebler.

смотреть в бинокль -
подсматривал за кем-то
смотрел в фотоаппарат - это
ешё и за собой

Диблог. Невозможно сфотографировать
метафизических сил
но можно добавить их в
созданием смотреть

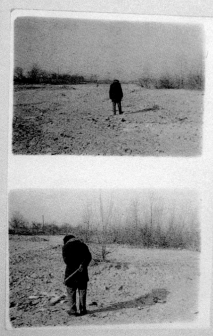

Как фотограф наделенной необычны-
ми полномочиями
Я как он выслеживаю, подсматриваю
подбираюсь
главное определить за кем

Untitled, from 'Unfinished Dissertation', Kharkov, Ukraine, 1985. The several hundred images in this series, often suggesting the 1920s and 30s and the Stalinist period of the Great Terror, were all taken during the dreary winter months of 1984. They were then randomly sequenced and the margins filled with text: scribble, autobiographical writings, remarks on his work, or extracts from Soviet literature on art, science and philosophy. Mikhailov compulsively covers the page, as if this incomplete dissertation, once consigned to the garbage, were a precious surface that cannot go to waste.

М. иохвидович.

Мировая волна Платона

Идея одновременно рождается и облетает весь мир.

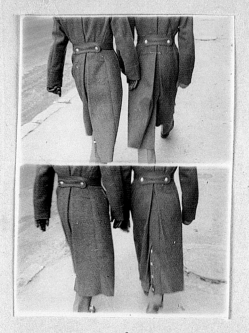

Недавно вдруг я полюбовался, что больше не хочется смотреть живопись и на весь Харьковский знакомый (кроме диктатор) ехал же в эти же дни же его волны.

И как-то особенно чувствуешь, что Маяковского сейчас надо оставить в покое. Мы и не видим сюрреалистический фильмъ Маяк.......... в группи, где мало волны. И Ничего

Untitled, from 'Salt Lake', Kharkov, Ukraine, 1986. The black-and-white series which the artist arranged for presentation in a loose-leaf book without text, i especially legible to a Western audience accustomed to the notion of the photo graph as social documentation. However, Mikhailov avoids any overtones o political accusation or 'human tragedy' by presenting these Soviet seasid bathers in the context of a simple story about a happy day out. The dozens o pictures are arranged as a narrative: the arrival at the car park; the pat to the salt lake; bathing in the warm salty water; holidaymakers standing aroun chatting, getting changed for the evening and returning home. As in a Mikhailov's works, there is no moral epitaph to the story, only the slow, crushin drama of eventlessness.

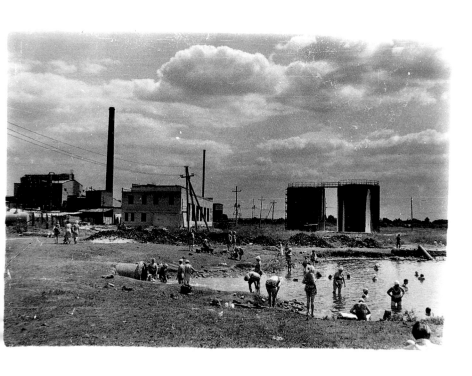

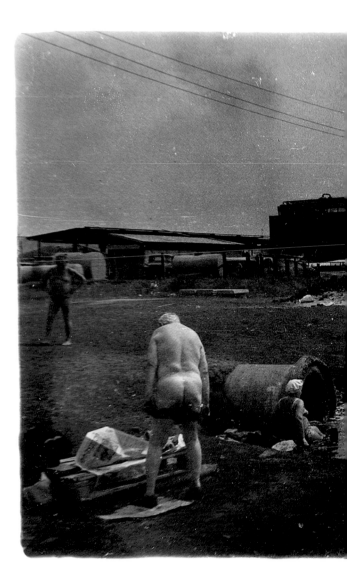

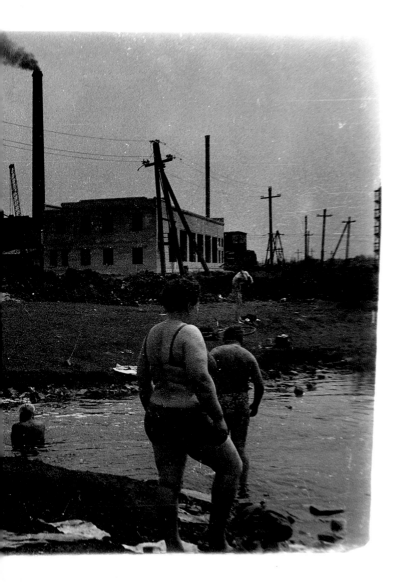

(previous page) **Untitled, from 'Salt Lake', Kharkov, Ukraine, 1986.** The water in the salt lake at the centre of this series is said to have a healing effect on gout, but there is little sign of health here: only rolls and rolls of Soviet flesh, thriving despite the hostility of the environment. Here, the human body, as in Mikhailov's later 'Case History' series (1997–8), is stripped of its beauty and even of its dignity. The nudity is more bestial than erotic: resembling nature photographs of wild animals gathering at a watering hole. However, the artist is careful to avoid exploiting the potentially humiliating moments of human existence that he captures. He documents his world as if from within, not as a voyeur but as a fellow, sympathetic member of Russian society.

Untitled, from 'Salt Lake', Kharkov, Ukraine, 1986. A group of health-seeking bathers gathers around a mysterious pipeline, seeming not to notice the toxic looking duct. The obliviousness of the subjects in 'Salt Lake' to their unpleasant surroundings renders the series a giant metaphor for the acquired indifference of the Soviet people towards the unkind landscape and social conventions around them. On the other hand, this photograph could be compared to Weegee's famous image of an overcrowded beach on Coney Island: in the US, as on this Soviet beach, the discomfort of the conditions does not outweigh the desire for seaside pleasure.

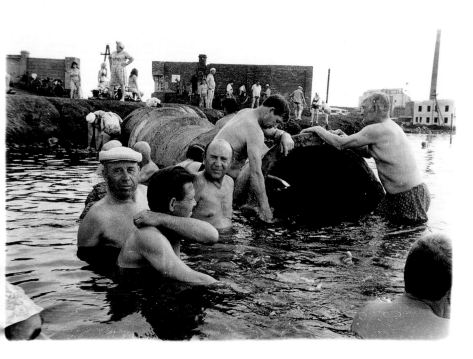

Untitled, from 'Salt Lake', Kharkov, Ukraine, 1986. The forlorn-looking tracks the grey landscape, the near-naked bodies and the anonymous chimney stack and barracks looming in the background form an unsettling cross between a seaside resort and a concentration camp. Mikhailov encourages such disparate references through his idea of 'parallel historical association', in which moments and places across time and space are drawn together. Images such as this reject eventful or aesthetic moments in favour of evoking an overcast atmosphere and a correspondingly grey state of mind.

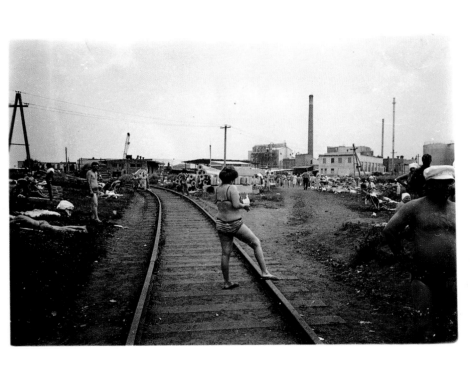

Untitled, from 'By the Ground', Kharkov, Ukraine, 1991. These sepia-toned panoramic prints of the streets of Kharkov and Moscow, shot from a camera hung low around the artist's waist, are considered among Mikhailov's most accomplished to date. Exhibited to great acclaim at New York's Museum of Modern Art in 1993–4, the title 'By the Ground' refers to Russian playwright Maxim Gorky's *The Lower Depths* (1902), whose characters were based mostly on the roadside outcasts he had met during his travels. Gorky's position as an artist who not only documented the injustices of society in his art but also acted against them in revolutionary activity, is analogous to Mikhailov's ethical position towards the artist's role: not as outside documentarist, but as an implicated co-participant.

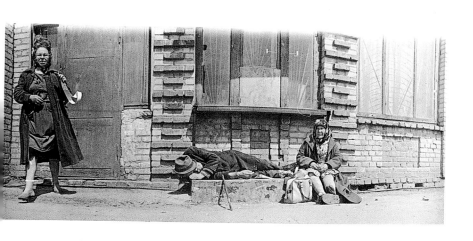

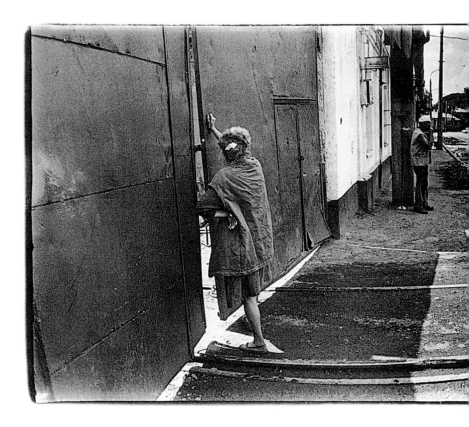

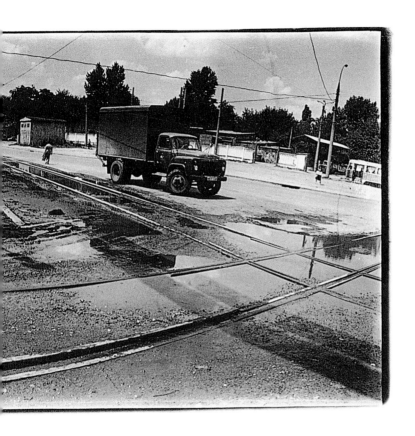

(previous page) Untitled, from 'By the Ground', Kharkov, Ukraine, 1991. Conventionally, the panoramic, 120-degree camera, with its sweeping, cinematographic view, documents open vistas, scenic beauty and epic events. In a deliberate stylistic contradiction, Mikhailov adopts this horizontal format to depict forgettable non-events set in claustrophobic, unremarkable places. When exhibited, the works were hung in a row, low to the ground. This unusual installation forced viewers to stoop towards the floor in order to get a good view, causing them to experience the bodily strain and discomfort of the worn-down, homeless people on view.

Untitled, from 'By the Ground', Kharkov, Ukraine, 1991. On occasion, the works in 'By the Ground' display the kind of detail and rich shades of grey associated with American landscape photographer Ansel Adams, who depicted wide-open American vistas – certainly not suffocating, urban images such as this. Ansel Adams used a classic, timeless style in order to connect his images with a past, unspoiled American frontier. Mikhailov similarly applies a sepia tint to suggest nostalgia and history – as well as dust and dirt – in associating contemporary, downtrodden Soviet society with the pre-Revolutionary era.

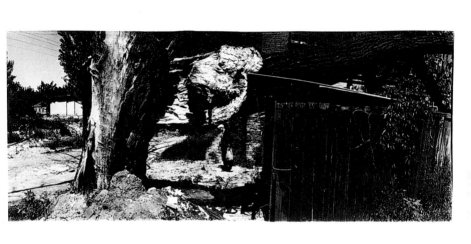

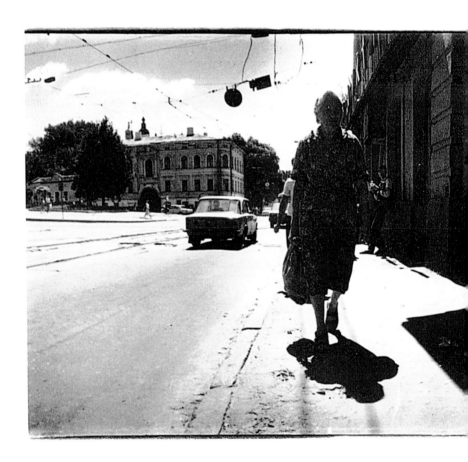

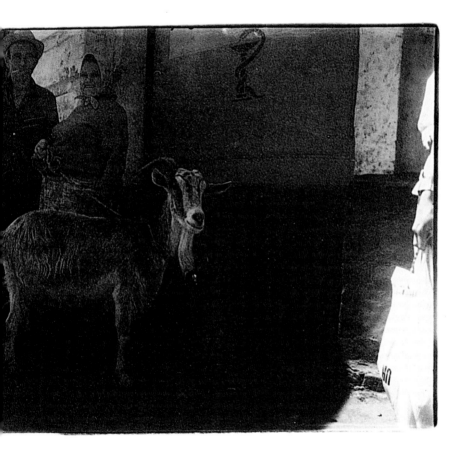

(previous page) Untitled, from 'By the Ground', Kharkov, Ukraine, 1991. In a work by fellow Soviet artist and friend Ilya Kabakov titled *The Palace of Project* (1998), Kabakov suggests to audiences that they improve their spirits simply by looking upwards. When we look towards the heavens, Kabakov explains, we experience 'an inflow of lofty, ennobling thoughts and feelings'. Here, Mikhailov's gaze follows the opposite of Kabakov's recommended perspective. Aiming his camera towards the ground, Mikhailov mimics the viewpoint of someone perpetually casting their eyes downward, as if in dejection and despair.

Untitled, from 'By the Ground', Kharkov, Ukraine, 1991. Mikhailov positions the camera at his belly, as if he were photographing from the gut, or shooting from the hip. His subjects are seen, in the words of critic Diane Neumaier, 'from the perspective, literally, of the dull hunger of the lower abdomen'. Refusing to view these scenes through the protective lens of the camera, Mikhailov looks at them directly. The camera positioned at the waist documents the image as if separate from the artist's gaze.

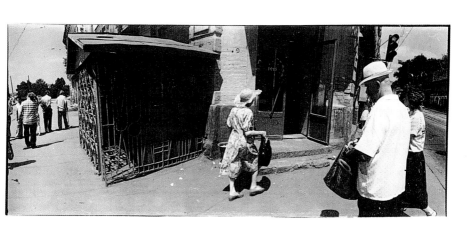

Untitled, from 'By the Ground', Kharkov, Ukraine, 1991. In one of Mikhailov
best-known images from 'By the Ground', we see young Kharkov girls playin
with mock military precision astride a grave-like excavation. The co-existence c
contradictory symbols, alluding both to life (carefree child's-play) and deat
('soldiers' hovering over an open grave) is typical of Mikhailov's work, whic
invites us to associate freely in response to his pictures, even interpreting the
with contradictory impressions. In exhibitions of 'By the Ground', Mikhailc
always hangs the same unframed, dog-eared prints, cheaply printed on poor
quality paper, as a kind of parallel to the impoverished, battered lives depicted.

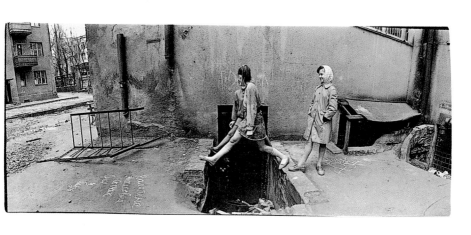

Untitled, from 'By the Ground', Kharkov, Ukraine, 1991. Soviet photographer Alexander Rodchenko once said, 'the most interesting visual angles of our age are the bird's eye view and the worm's eye view' – presumably to capture the sweeping, glorious changes produced by the Revolution. Here, Mikhailov toys ironically with the optimism of early Soviet photography, applying the 'worm's eye view' to show the bleak failure of the Soviet social experiment as a low, dark expanse.

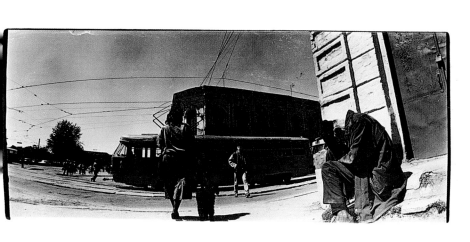

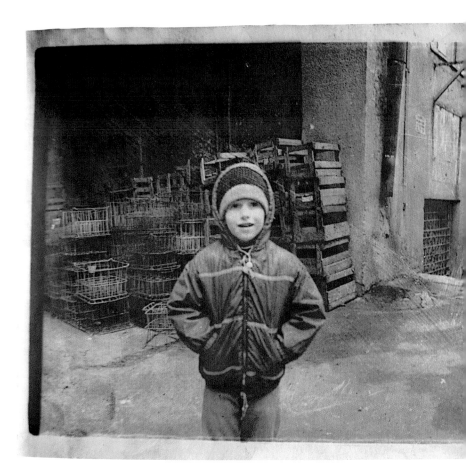

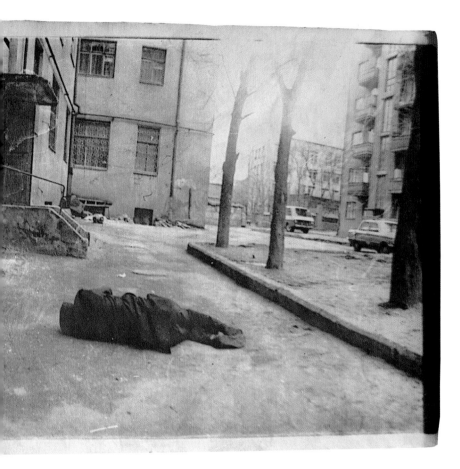

(previous page) **Untitled, from 'At Dusk', Kharkov, Ukraine, 1993.** 'At Dusk' followed directly on from 'By the Ground', but is more haunting, darker and still more dramatic. The works reference the artist's memories of World War II, and the blue tone derives from an autobiographical memory. Mikhailov recalls the terrifying sirens that awakened him in the middle of the night as a child evacuee in the Urals. The dark blue tones make reference to this nightmare.

Untitled, from 'At Dusk', Kharkov, Ukraine, 1993. These horizontal-format pictures are broad vistas on a desperately unhappy world and seem bitterly connected to another era: the class struggle under the Tsars; the Stalinist Great Terror; the concentration camps of World War II. Here, the figures are caught in the murk of fear and poverty, heads bowed. In other images there are unexplained glimpses of people being pursued by uniformed men, suggesting a frightening post-Soviet world that seems to be populated exclusively by victims and assailants.

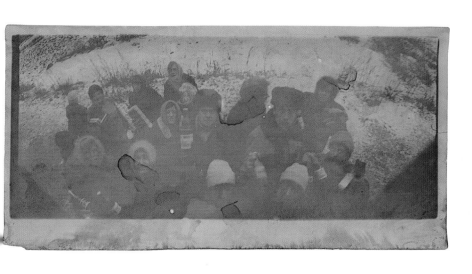

Untitled, from 'At Dusk', Kharkov, Ukraine, 1993. Easily one of the artist's most disturbing series, this group was meant to be the central section of a trilogy: 'By the Ground', nostalgically coloured in sepia tone; 'At Dusk', tinted in blue, 'the colour of the blockade, of hunger and war' (Mikhailov); and the never-realized 'At Sunrise', conceived as a slightly more redemptive series, tinted magenta, as if seen through rose-coloured glasses. The dark blue is meant to connect the past horrors of World War II with the present emergence of a 'society of wolves' — the newly capitalist society depicted here.

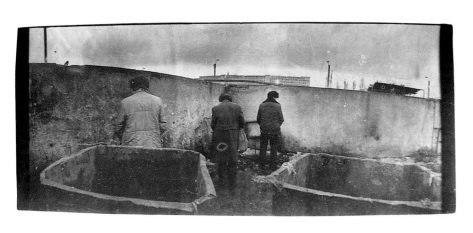

Untitled, from 'At Dusk', Kharkov, Ukraine, 1993. In this, one of Mikhailov's rare symmetrical images, the severe, almost classical composition of straight lines in vanishing one-point perspective contrasts with the crudely graffitied hammer and sickle at the centre. The primitive scrawl of the Communist symbol clashes with the grey efficiency of the surrounding railway; and yet the ideology behind this bold, hand-written symbol seems solid, closer to the spirit of the unseen Soviet citizens than the machine-made railroad tracks stretching far into the empty horizon.

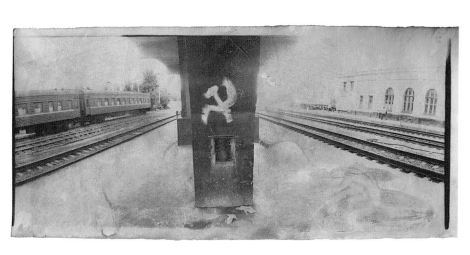

Untitled, from 'I Am Not I', Kharkov, Ukraine, 1992. In this series of self portraits, the artist most plainly dramatizes his ambiguous and ethically difficult position: that of a respected artist with a paying Western audience, who has built his work on the foundation of bleak, Soviet social reality. In these pictures, he assumes mock-athletic or contemplative poses reminiscent of nineteenth century nudes, absurdly overacted by today's standards. Here, he mocks himself, confessing to the vanity of an elderly, melancholy man posing as an improbable sex symbol. The machismo of the artist is rendered ludicrous as he emulates the histrionics of a self-obsessed star, or of a tyrant, recalling the camp, dramatic poses of Hitler or Mussolini.

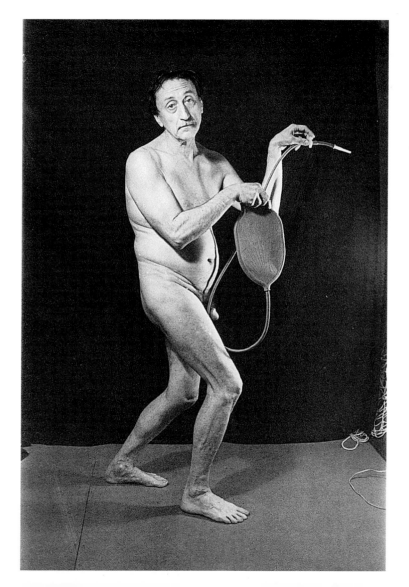

Untitled, from 'I Am Not I', Kharkov, Ukraine, 1992. Here, Mikhailov sits pensively in a caricature of Rodin's *The Thinker*. Mocking himself, he presents the intellectual/artist as an isolated and pathetic individual, occupying a self-enclosed, self-absorbed world. In this series Mikhailov goes to great lengths to shed the aura of self-importance and worthiness in his art, laying himself vulnerable to ridicule. 'The photographer,' he explains, 'is not a hero.'

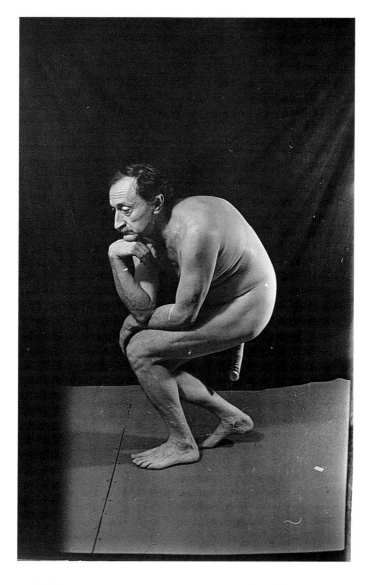

Untitled, from 'I Am Not I', Kharkov, Ukraine, 1992. In these highly staged photographs set up in the artist's studio, Mikhailov uses props – wigs, sword, chair, artificial phallus – to heighten the sense of burlesque theatricality. The use of dramatic lighting, black-and-white film and a poster-sized format make ironic reference to the idealized, screen-star pictures of Hollywood. This image is a parody of macho sexuality. The day before the official opening of an exhibition of these works, planned at the Kharkov art museum in 1995, Ukrainian officials cancelled the show on the grounds that the series contained nudity and pornography.

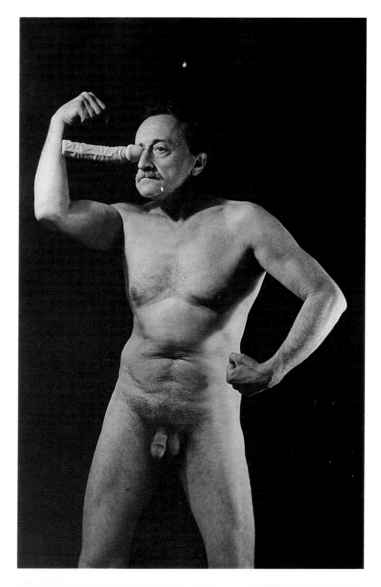

Untitled, from 'If I Were a German', with Vita Mikhailov, Sergei Solonski, Serge Bratnov, Kharkov, Ukraine, 1994. In this, one of the artist's most controversial series, Mikhailov and friends dress as Nazi officers and enact erotic encounters, presumably between victim and tormentor – encounters that the victims seem strangely to enjoy. The meaning behind these staged, tragicomic, black-and-white images is ambiguous: do they suggest mutual complicity and even perverse pleasures derived from adopting the position of victim, or are they allegorical, dream images that allow the victim finally to take revenge on the executioner?

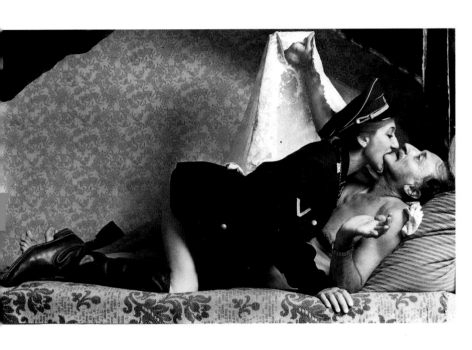

Untitled, from 'Case History', Kharkov, Ukraine, 1997–8. Unable to ignore the obvious tragedy around him, Mikhailov produced this powerful body of work which takes as its subjects the *bomzhes*, or homeless community, of Kharkov. Of all his series, it adheres most purely to Western expectations of social documentation. Mikhailov was acutely aware of the difficulty of his ethical position. 'On the one hand, for myself personally I understand that taking pictures of poverty was my professional and civil duty,' he said. 'On the other hand I accept traditional clichés about "not using others' grief".' But what does "others' grief" mean? And how must a photographer behave?'

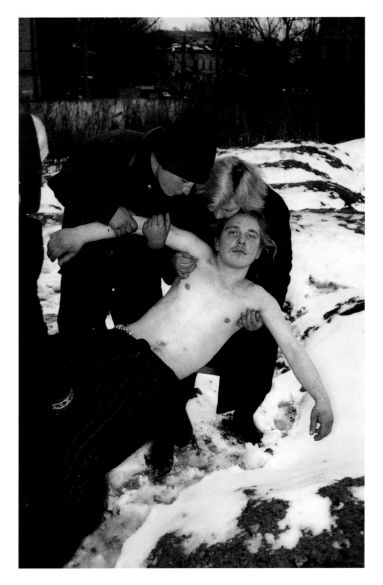

Untitled, from 'Case History', Kharkov, Ukraine, 1997–8. Comprising nearly 500 photographs, 'Case History' explores the tragic results of the final dismantling of the Soviet myth. The homeless become like players in some existential tragedy, human casualties of history. The artist chose to participate in the brand-new capitalist system by paying his subjects to pose for him. 'Manipulating with money is somehow a new way of legal relations in all areas of the former USSR,' said Mikhailov. 'I wanted to copy or perform the same relations that exist in society between the model and myself ... The people depicted didn't really have a choice: they either posed or they vanished.'

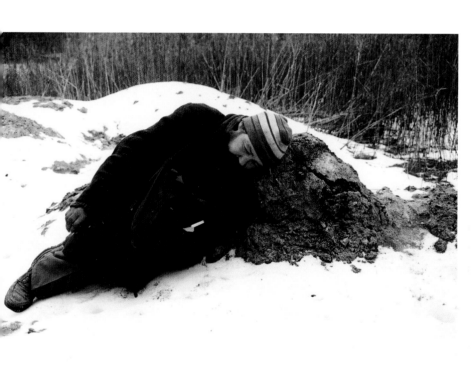

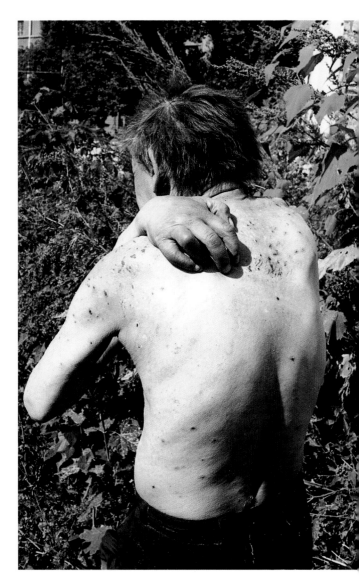

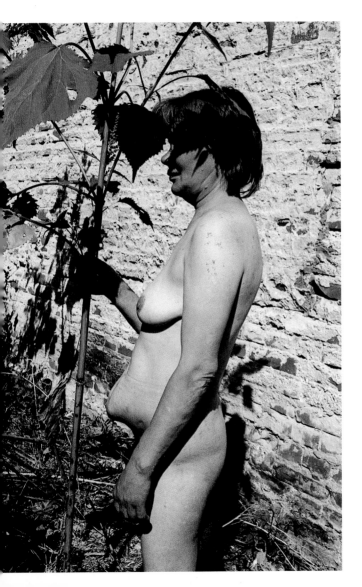

(previous page) Untitled, from 'Case History', Kharkov, Ukraine, 1997–8. 'These colour photographs', says Mikhailov, 'are like the rash on an ill body.' With this series, the artist returned to colour photography, which he had not used since 'Sots Art'. The use of colour, like paying his subjects to pose for him in this series, is a reference to the post-Soviet emulation of the Western way of life. '[With] the appearance of Western technology ... both the rich and the poor wanted to have colour photographs. There was only one distinction: the rich could afford them, the poor couldn't.' Even in snapshot photography, allegedly the most 'democratic' of visual means, the class system remains firmly in place.

Untitled, from 'Case History', Kharkov, Ukraine, 1997–8. Mikhailov photographed the *bomzhes* when they were new to the group, before they had hardened irreversibly beyond human recognition. Here he is almost an anthropologist, observing the class psychology and clan-like dynamics of the group. The subjects are sometimes clothed, sometimes not. As in much of Mikhailov's work, the animal-like physicality of the human body – naked, sexualized, hungry, cold – is disturbingly apparent. Yet their nakedness also endows them with a degree of human dignity. 'When naked,' the artist says, 'they stood like people.'

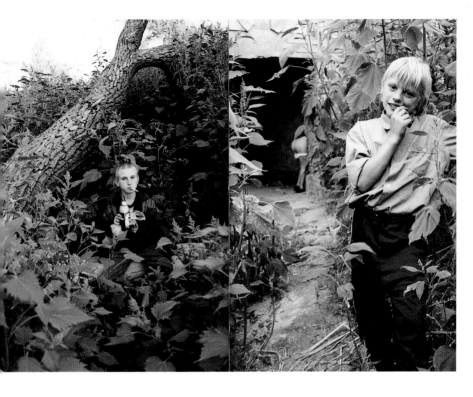

1938 Born 25 August in Kharkov, Ukraine.

c.1941 Evacuated to the Urals as German army approaches.

1962 Obtains job as a technical engineer in the Kharkov Camera Works

c.1965 Takes his first photograph – of a woman smoking a cigarette, an illicit subject in the Soviet Union at that time. The work is rejected by every exhibition to which it is submitted.

1966–1968 Asked to produce a short film about his factory. Welcomes the opportunity as a creative escape. He also uses the camera to take a series of nude photographs of his wife. They are seized by the KGB, and he loses his job. Decides to devote himself entirely to photography and obtains a job as a technical photographer. Retouches old family photographs as a sideline. Makes the 'Superimposition' series, consisting of two slides projected one over the other.

1968–1975 Makes the 'Red Series', photographs of the ritual pageantry to the glory of the Revolution.

1971–1985 Uses the hand-coloured portraits of families, young soldiers and couples that he makes in his second job as 'found' photographs to make the 'Luriki' series.

1975–1986 Creates the 'Sots Art' series, hand-coloured pictures which explore political themes through the depiction of everyday scenes.

1981 Makes 'Beach at Berdiansk' series of black-and-white photographs of Soviet citizens on holiday.

1982 Creates 'Crimean Snobbery', a staged series of images of him and a group of friends at a seaside resort in the Ukraine.

1985 Uses the pages of a discarded, unfinished dissertation as a background for photographs and autobiographical writings in the 'Unfinished Dissertation' series.

1986 Produces 'Salt Lake', a series of documentary photographs.

1991 Makes the series 'By the Ground'. Exhibition of his work is held at the Hasselblad Center, Goteborg, Sweden.

1992 Parodies his own artistic persona in 'I Am Not I', a series of nude self-portraits.

1993 Produces 'At Dusk' series, 13 blue-toned panoramic photographs recalling his time as a child evacuee in the Urals.

1994 With his wife, Vita, and other friends he makes 'If I Were a German'.

1995 Exhibition of his work at the Institute of Contemporary Art, Philadelphia, USA.

1996 Exhibits at the Kunsthalle, Zürich.

1997–1998 Awarded a grant by the DAAD (German Academic Exchange Service) and moves to Berlin. Wins the Albert Renger-Patzsch Buchpreis awarded by the Museum Folkwang, Essen, Germany. Makes 'Case History', where he experiments with hiring the homeless as his subjects. Publishes *Unfinished Dissertation*. Exhibition of his work held at the Stedelijk Museum, Amsterdam, Holland.

1999 Publishes *Case History*. Exhibition of his work held at the Centre National de la Photographie, Paris.

2000 Wins the prestigious Hasselblad Foundation International Award for Photography. Spends a semeseter at Harvard University, US, as Visiting Professor in the Department of Visual and Enivironmental Studies.

2001 Awarded the Citibank Photography Prize, the UK's major photographic award. *Case History* wins the Kraszna-Krausz prize.

Photography is the visual medium of the modern world. As a means of recording, and as an art form in its own right, it pervades our lives and shapes our perceptions.

55 is a new series of beautifully produced, pocket-sized books that acknowledge and celebrate all styles and all aspects of photography.

Just as Penguin books found a new market for fiction in the 1930s, so, at the start of a new century, Phaidon **55**s, accessible to everyone, will reach a new, visually aware contemporary audience. Each volume of 128 pages focuses on the life's work of an individual master and contains an informative introduction and 55 key works accompanied by extended captions.

As part of an ongoing program, each **55** offers a story of modern life.

Boris Mikhailov (b.1938) is the former Soviet Union's most influential living photographer. His varied photographic strategies demonstrate not only a rich imagination but also practical solutions for survival in an unstable and unsafe world. His art seems to embody a search for his own identity, as well as questioning how an artist can position himself in a defeated, dying world.

Gilda Williams is a critic and curator of contemporary art and photography. Formerly Managing Editor of *Flash Art International* she is currently Commissioning Editor for contemporary art at Phaidon Press.

Phaidon Press Limited
Regent's Wharf
All Saints Street
London N1 9PA

Phaidon Press Inc.
180 Varick Street
New York NY 10014

www.phaidon.com

First published 2001
©2001 Phaidon Press Limited

ISBN 0 7148 4066 1

Designed by Julia Hasting
Printed in Hong Kong